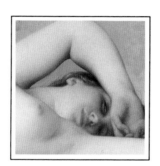

THE ART OF

THE NUDE

Deirdre Robson

A Compilation of Works from the
BRIDGEMAN ART LIBRARY

SHOOTING STAR PRESS

The Nude

This edition printed for :
Shooting Star Press Inc.
230 Fifth Avenue – Suite 1212
New York, NY 10001

Shooting Star Press books are available at special discounts for bulk purchases
for sales promotions, premiums, fund-raising, or educational use. Special
edition or book excerpts can also be created to specification. For details
contact: Special Sales Director, Shooting Star Press Inc.,
230 Fifth Avenue, Suite 1212, New York, NY10001

© 1995 Parragon Book Service Limited

ISBN 1-57335-030-3

Printed in Italy

Editors: Barbara Horn, Alexa Stace, Alison Stace, Tucker Slingsby Ltd and
Jennifer Warner.
Designers: Robert Mathias and Helen Mathias
Picture Research: Kathy Lockley

The publishers would like to thank Joanna Hartley at the Bridgeman Art
Library for her invaluable help.

THE NUDE

THE FRENCH POET, Paul Valery, noted that the nude is for the artist what love is for the poet and indeed the nude has been a well-spring of artistic creativity in European art, so perennial that one can virtually trace the history of Western art via it. It has always acted as the visual embodiment of ideas and views about that most constant of human concerns, love, whether earthly or sacred.

For the Ancient Greeks the nude epitomised perfect physical beauty of a kind immune from the depredations of time; signified the imposition of order upon the caprices of nature; and symbolised the nobility of the human spirit. It was an art form usually reserved for representations of the deities, while portraits of actual people were generally clothed.

In contrast, during the Medieval era the naked body stood for temptation and sin. In Christian theology the emphasis was not upon physical beauty but upon the inevitability of the body's decay and the shame in nakedness which came from eating the fruit of the tree of knowledge: 'And the eyes of them both were opened and they knew that they were naked; and they sewed leaves together and made themselves aprons.' Representations of the naked body were rare and restricted to the Temptation, the Last Judgement and the torments of Hell.

Many Classical ideals were rediscovered during the Renaissance, when the general tenor of philosophy became humanist. Once again the nude became an embodiment of perfect beauty and an emblem of abstract concepts such as Beauty, Genius, Friendship, Truth or Sacred Love. More practically, the rediscovery in Rome in the 15th century

onwards of antique statuary such as the Apollo Belvedere or Medici Venus provided contemporary artists with models for their art, while the Church's new tolerance of the study of anatomy made a working knowledge of the human body possible. From the late 16th century onwards drawing from life became a key part of any artist's training.

The importance of the nude persisted through 17th century baroque art well into the 19th century, though from the 18th century onwards it was gradually challenged by the increasing popularity of genre (everyday subjects) or landscape art. The nude retained its significance because of its connection with subjects of the highest cultural status, whether religious, allegorical or mythological. As such subjects tended to be favoured more by aristocratic or ecclesiastical patrons, there grew a geographic unevenness in the popularity of the nude. One was more likely to find nudes painted in Catholic countries, such as Italy or Flanders, or countries with a strong tradition of State patronage, such as France, than in bourgeois states such as Holland or Britain whose publics tended to favour portraits or genre subjects.

The term 'nude' has now become almost synonymous with 'female nude'; this is because over time the latter has been most common, perhaps because most artists (and patrons) have been men. In Classical Greece, however, the male nude formed the linchpin of artistic practice and female nudes, such as the Venus de Milo, were rare until the 3rd century BC. This is almost certainly because of the unequal positions of men and women in Athenian society and because in this society the highest form of love was thought to be homosexual rather than heterosexual. It was only with some change in the position of women and a re-assessment of the status of heterosexual love that female nudes made an appearance. During the Renaissance attention was initially paid to both male and female nudes but by the 16th century the emphasis was firmly upon the female and this continued to be the case.

It is also possible to point to key differences in the way each sex has been represented. Typically, the male nude is active, the female passive. This separation, crucial in antique art, continued into the Renaissance. In the latter era, the most characteristic type of female

nude becomes the reclining figure introduced by Giorgione's Sleeping Venus, an interesting innovation because there were no known ntique models for it. Male nudes, in contrast, such as Michelangelo's David, are much more varied and vigorous in character.

The consistent element running through the nude in art of all ages has been sexuality, an inevitable consequence of either being unclothed or gazing upon naked flesh. How to deal with this sexual quotient, has always been an issue for supporters of the nude. Despite the lip service paid since the Renaissance to the ideal of the nude, artists have often had battles with patrons and public as to what they might, or might not, represent. One way in which the nude has been made 'safe' is that it has been aestheticised, discussed solely in terms of colour and composition, thus obscuring the fact that a naked human (and usually female) body has been represented (usually by a man) and that an erotic or sexual charge is almost inevitable within European culture. By this means an extraordinarily varied range of images has been granted ostensibe respectability.

Challenges to the conventional notion of how a nude should be portrayed and what meanings it could carry, came with escalating frequency from the 18th century onwards. Although Neo-classicism in the late 18th century tried to reinforce the primacy of the nude and looked for inspiration to the sculpture of the Ancient Greeks, in the 19th century the idealism of the nude became increasingly devalued, a matter of form and not spirit. The nude came to be associated with a kind of oblique, 'safe' sexuality characterised by a smooth, polished painting style and sentimentalised literary subjects. Because of this the nude became a focus for artists who wished to challenge these beliefs, as in the case of Manet's Olympia. In the 20th century the nude has become relatively uncommon but some of the most shocking contemporary art has been in this format (Robert Mapplethorpe's photographs of the naked male, for example), its impact perhaps enhanced by the way it attacks expectations.

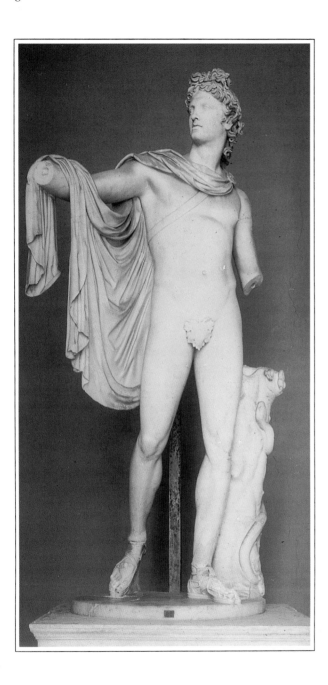

◁ **Apollo Belvedere** Anon Roman copy of Greek original, probably 5th century BC

Marble

The Apollo Belvedere is a representation of the god Apollo, traditionally shown as youthful and handsome. It exemplifies the approach to male beauty characteristic of classical Athens in the fifth century BC, in which a new realism regarding anatomy and bodily detail was combined with an idealisation which signified divine status. At this time sculpture concentrated upon the male nude, probably because Athenian society was one in which homosexual love was seen as superior to heterosexual. When rediscovered in Rome in 1479 the Apollo Belvedere became a focus of the Renaissance's burgeoning interest in the art of the Classical world; a model for artists attempting to create a new, more human-centred art. In the 18th century it became the object of Neo-classicist enthusiasm and Winckelman described it as: 'the highest ideal of art among all the works of antiquity'.

▷ **Venus de Milo** Anon
Hellenistic, 2nd century BC

Marble

NAMED AFTER its site of
discovery, Melos, this statue is
one version of a theme
introduced to classical
sculpture in the Hellenistic
period (3rd century BC), the
naked or near-naked
Aphrodite (or Venus as she
was known to the Romans),
goddess of sexual love. Before
this time there had been very
few representations of female
nudity. This statue would,
because of its religious
purpose as a representation of
the goddess of love, have been
meant to evoke an erotic
response (essentially that of
the male spectator, for art was
produced by men for men).
Despite this fact, Venus as
shown is quite modest, even a
bit matronly, her face rather
expressionless. The
appearance of female
goddesses of this type seems to
parallel shifts in attitudes
towards the position of women
and towards the status of
heterosexual love.

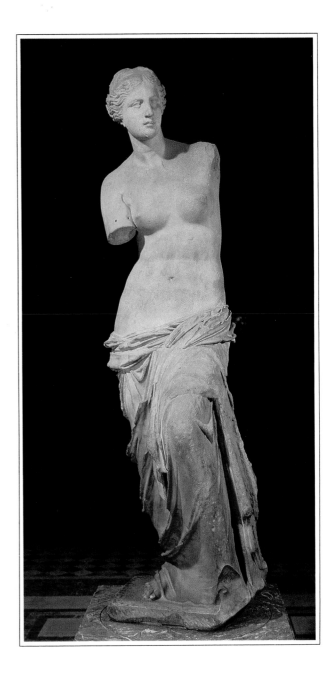

Detail

▷ **Adam and Eve in the Garden of Eden**
Pol de Limbourg (c.1402-16)

(The Tres Riches Heures du Duc du Berry) (1416)

ONE OF THE high points of the International Gothic style, the *Tres Riches Heures du Duc du Berry,* an illuminated collection of texts, is a monument to his advanced taste. The miniature illustrations combine the jewelled brilliance of Medieval manuscripts with compositional motifs derived from Italian wall- painting. In most respects this representation of the Garden of Eden is Gothic in its emphasis upon the decorative, its brilliant jewel-like colour and its apparent lack of interest in proportion and perspective. But the inclusion of nude figures of Adam and Eve shows the possible influence of Italian painters visiting the French court, even if the rendition of Eve is, by subsequent Renaissance standards rather archaic or anachronistic in its high-breasted, pot-bellied body type.

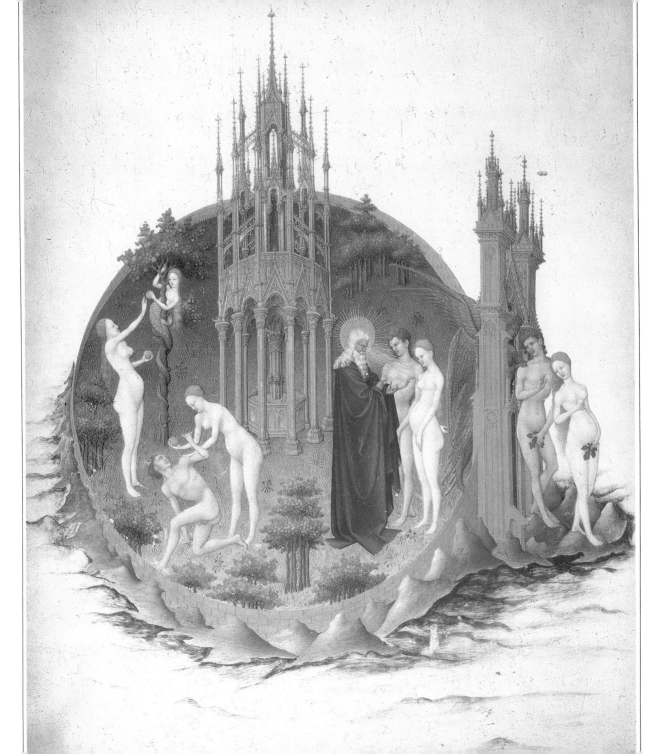

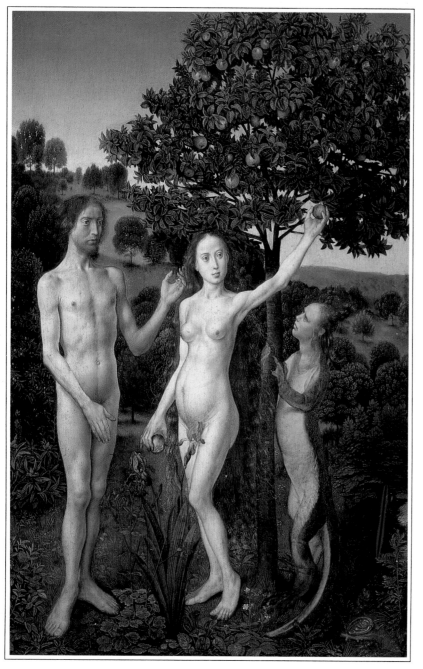

◁ **Adam and Eve**
Hugo van der Goes (c.1482)

Oil on canvas

THE EARLY RENAISSANCE DATE
and Northern European
origin of this work are
betrayed by the relatively
wooden depiction of Adam
and the body type of Eve,
slim, high-breasted and full-
stomached. But the relative
lack of physical beauty,
particularly female beauty, is
expressive of the role in which
Eve is cast in this and similar
paintings – a sinful temptress,
to be condemned for her
disobedience rather than
desired for her fleshly charms.
Adam and Eve are depicted at
the moment of temptation but
before the point of no return
as Eve, having plucked an
apple for herself, reaches for
one for Adam, encouraged
by the strangely female
serpent. A premonition of the
sense of shame to come is
signified by the strategic
placing of Adam's hand and
the iris in front of Eve.

▷ Adam and Eve Banished from Paradise
Tommaso Masaccio (1401-1428)

Fresco

ONE OF THE GREAT innovations
of the early Renaissance was a
concern with representing the
appearance of humankind and
its surroundings with more
accuracy. This painting is part
of a fresco (wall painting) cycle
which also shows the
Temptation. Masaccio's
treatment of Adam and Eve
contrasts strongly with that of
Northern European painters
of the same time or even fifty
years later. Although the
composition as a whole has
much of the Gothic in its
disposition of the figures both
Adam and Eve show
Masaccio's mastery of the new
approach to the human body.
The forms of Adam and Eve
recall classical models (Eve is
very like the Medici Venus in
gesture) and are remarkable
not only for their realism but
for the way in which they
express their awareness of the
tragedy of their situation,
particularly the way in which
Eve covers her body.

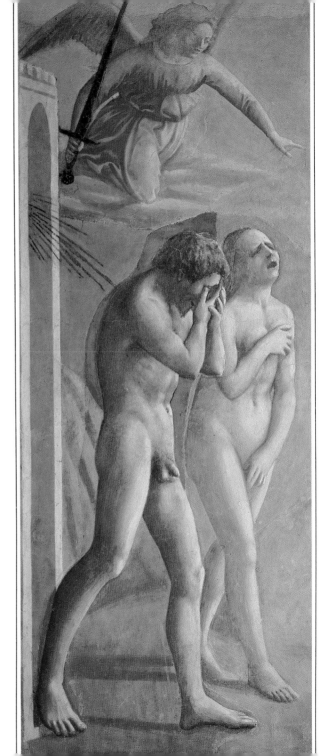

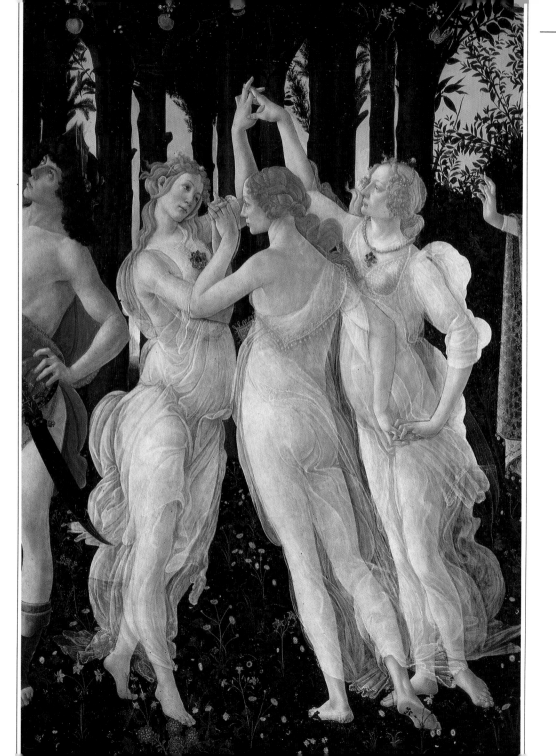

◁ **Primavera** (detail, *The Three Graces*) Sandro Botticelli (1445-1510)

Tempera on panel

PAINTED FOR ONE of the Medici family, Primavera was based upon a poem by Polizano, a Florentine humanist. In the centre stands the pregnant figure of Spring, to the right are Flora and a nymph pursued by the north wind, to the left Mercury and the Three Graces. The exact meaning of the whole allegory has always been disputed but the Three Graces were usually interpreted as signifying liberality. The whole painting demonstrates an amalgam of both Quattrocento (early Renaissance) and Renaissance approaches to art. The Graces are both solid and graceful, their sinuous charm heightened by the diaphanous draperies yet balanced by the sense of solid flesh and muscle beneath; the joy of their dance somehow countered by their wistful expressions.

The Birth of Venus Sandro Botticelli (1445-1510)

Tempera on wood

▷ *Overleaf page 16*

THE SUBJECT IS DERIVED from the classical myth that Venus was born from foam created when the castrated Uranus's genitals were cast upon the seas. Botticelli represents the moment when, propelled by the Zephyrs (winds) and greeted by the Seasons (here represented by the figure of Spring), Venus is wafted to shore. Venus, as personification of perfect beauty and thus truth, must be seen in the context of the Renaissance's new interest in classical ideas. The pose and sculptural treatment are derived from the Medici Venus but this is not simply a classical borrowing and still shows the graceful elongations of the international Gothic style. Indeed the whole mood is quite un- classical. The almost melancholic cast to Venus' features is quite unlike any classical prototype while the sculptural quality of the central figure is countered by the agitated rhythmic line used to depict the hair of Venus and Spring's draperies.

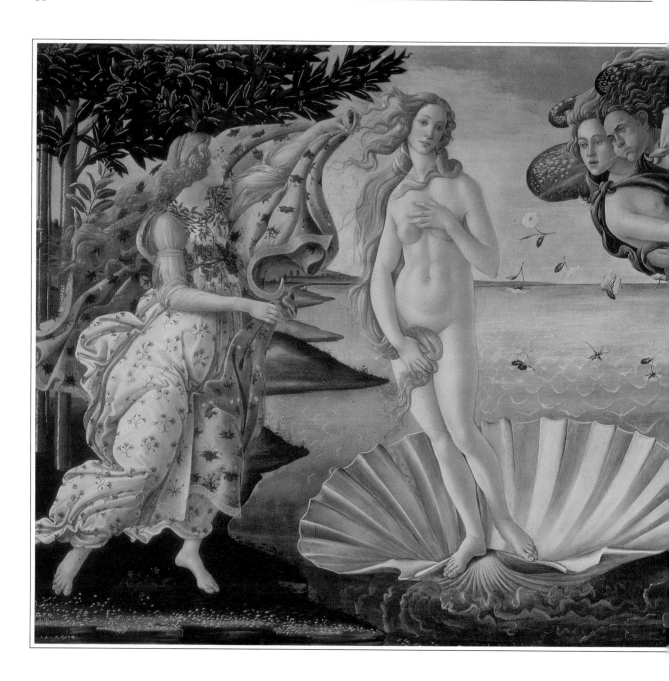

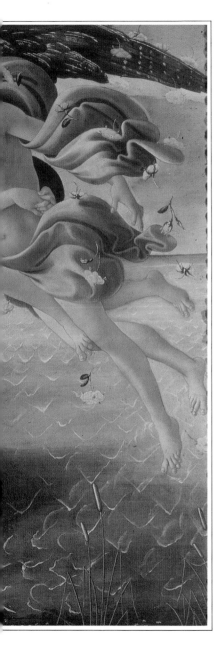

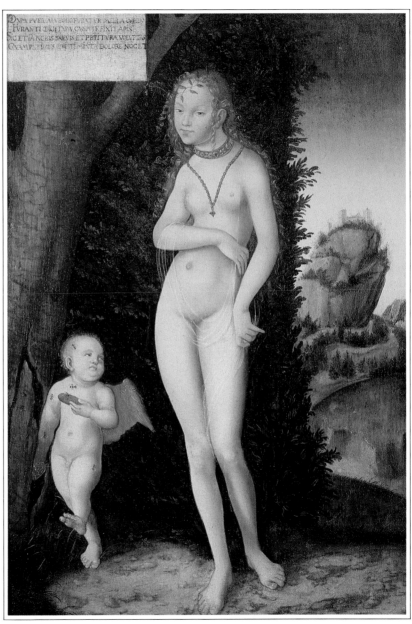

**Venus with Cupid the
Honey Thief**
Lucas Cranach (1472-1553)

Oil on canvas

◁ *Previous page 17*

THE SOURCE FOR this painting
is a 3rd century BC poem by
Theocritus, 'The Honey
Stealer', on the painful
consequences of seeking
sexual pleasure and is one of
several treatments of the same
subject by Cranach. Venus,
goddess of love, is shown
accompanied by her son,
Cupid. The honeycomb he
holds is a symbol of the joyful
consequences of the sexual act
but also points to the dangers
inherent in that pursuit, for
the stinging of the bees
symbolises the pain of
unrequited love or the
possibility of illness. Despite
the classical subject, this
northern European Venus
owes nothing to Classical art.
Instead her unclothed allure is
heightened by her willowy
body, her fine jewellery and
tumbling curls, her charms
barely hidden by the
strategically falling diaphanous
drape.

▷ **Gabrielle d'Estrees and her
sister, the Duchess of Villars**
School of Clouet

Oil on panel

A VERY RARE NUDE which does
not seem to hark back either to
Classical or Biblical sources,
this painting is thought to
represent the French King's
mistress, Gabrielle d'Estrees,
accompanied in the unusual
half-length pose, by her sister.
The Duchess of Villars touches
the breast of Gabrielle
d'Estrees, in allusion to the
impending birth of the Duc de
Vendome, the King's son.
Note the servant preparing
baby linen in the background.

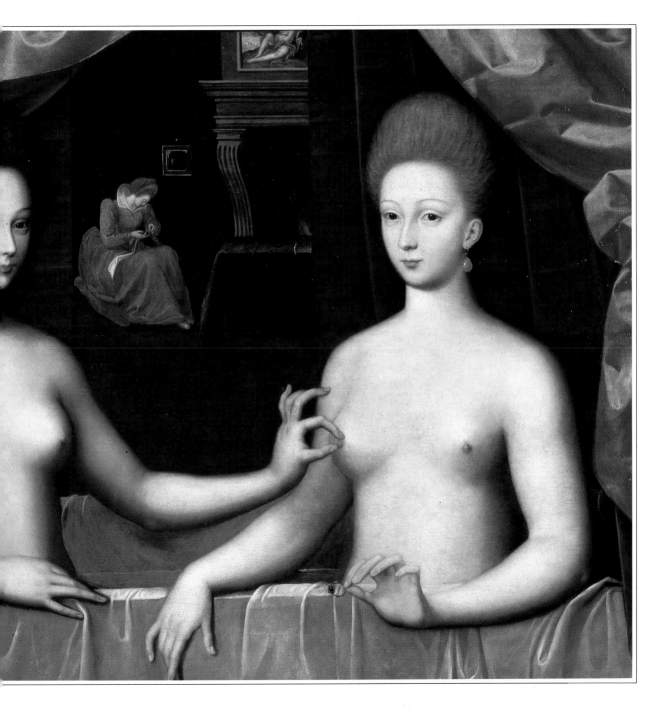

▷ **Battle of the Ten Nudes** Antonio Pollaiuolo (c.1432-98)

Engraving

THE NUDE BECAME the benchmark of an artist's mastery of anatomy and perspective and so, during the Italian Renaissance, artists would adopt themes, such as this one, allowing them to demonstrate their skills. Trained as a sculptor, Pollaiuolo excelled especially in representing the human form, particularly the male, in terms of line. This engraving, though it could be interpreted as re- creating the kind of battle scenes depicted on Antique sarcophagi (stone coffins), is really no more than a many-sided representation of the male body, designed to show the musculature in a variety of active positions. Each muscle is delineated in careful, even minute detail, in a way which recalls the drawings in anatomical treatises.

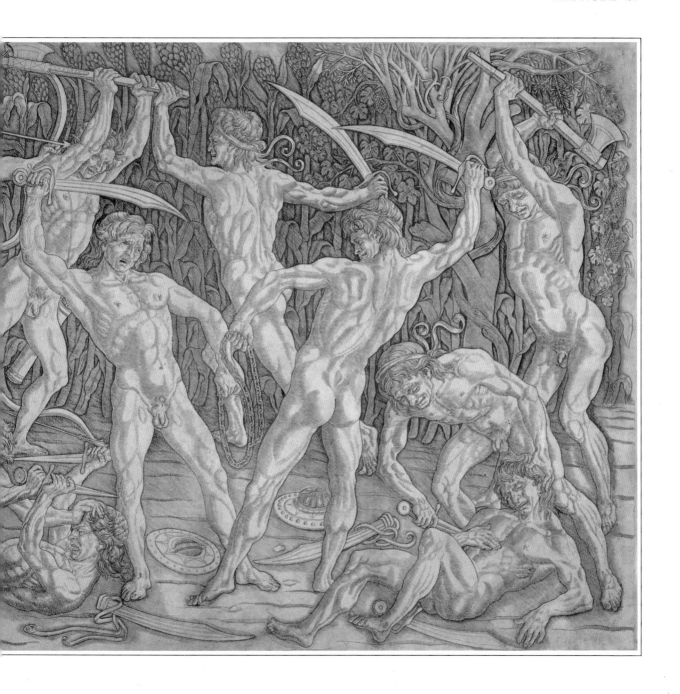

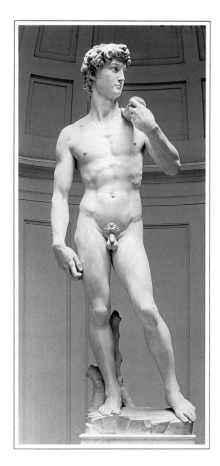

◁ **David**
Michelangelo Buonarotti
(1475-1564)

Marble

ONE OF THE HIGH POINTS of
Renaissance statuary, this
image of male youth and
beauty harks back directly to
Antique sculpture. Active and
dynamic, this depiction of the
male nude must be seen in
contrast to the more passive
female nude which Giorgione
and Titian were to make
famous. Based on the Biblical
story of David and Goliath and
inspired by the Apollo
Belvedere, David was
commissioned by the ruling
Medici family as a Florentine
commemoration of the power
of Republican Rome (by
implication drawing a parallel
between Republican Rome
and early 16th century
Florence). Its somewhat
idealized proportions and
calm features were meant to
express spiritual courage and
noble vigour in the face of
danger. In a pose of contained
energy, David's body is at
momentary rest, the main
symbol of his struggle being
the slightly enlarged size of his
hands.

▷ **Expulsion of Adam and Eve**
Michelangelo Buonarotti
(1475-1564)

Fresco

POPE JULIUS II commanded
Michelangelo to paint the
Sistine Chapel ceiling despite
his protestations that he was a
sculptor. The whole cycle
contrasts the Old and New
Testaments and emphasizes
two of the main Judaeo-
Christian beliefs: the One God
and the hopelessness of
humankind when left to itself.
What is remarkable in this
painting is how the human
body carries such meanings.
In the Temptation on the left,
a Junoesque Eve coolly
stretches out her hand to the
the Serpent, while the
unsteady position of Adam
seems to indicate his greater
uncertainty. In contrast, in the
Expulsion on the right, the
figure of Adam is much the
stronger. He seems to be
swatting away the point of the
angel's sword while Eve
crouches beside him,
despondent in her realisation
of the awful consequences of
her action.

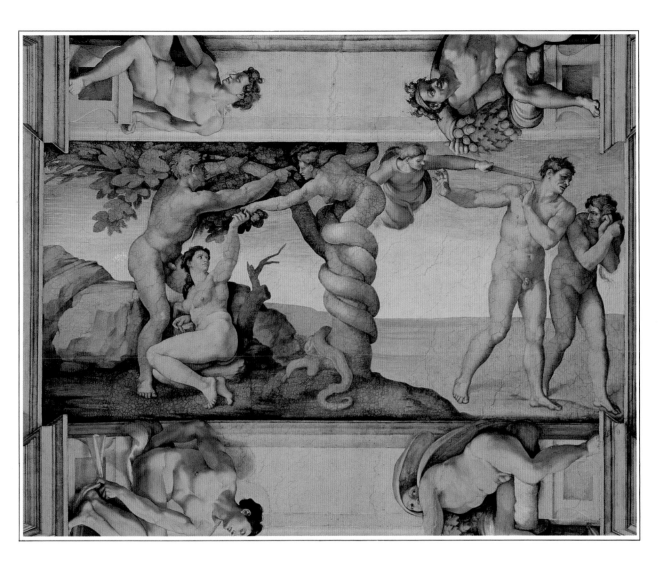

▷ **The Venus of Urbino** Titian (c.1487/90-1576)

Oil on canvas

RECLINING FEMALE NUDES were extremely rare in the art of antiquity and the source for the idea first seen in Giorgione's *Sleeping Venus* (c.1505) is unknown. Subsequently, however, this type of female nude, particularly as popularised by Titian in paintings such as this one, became one of the mainstays of European art. Venus is reclining on a silken bed, clutching a bunch of red roses, a dog at her feet and there are suggestions of the toilette in the activity of the maidservants in the background. Though ostensibly a depiction of ideal beauty – her status being intimated by the flowers she holds (a substitute for the more usual pastoral landscape) – this Venus, commissioned by the Duke of Urbino, has a very earthy quality to her sensuousness. She appears quite aware of her charms and, unusually for a representation of the female nude, seems to be gazing at the spectator.

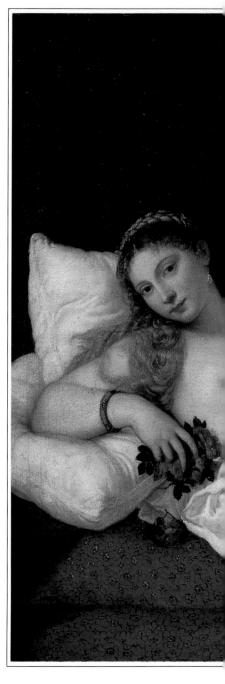

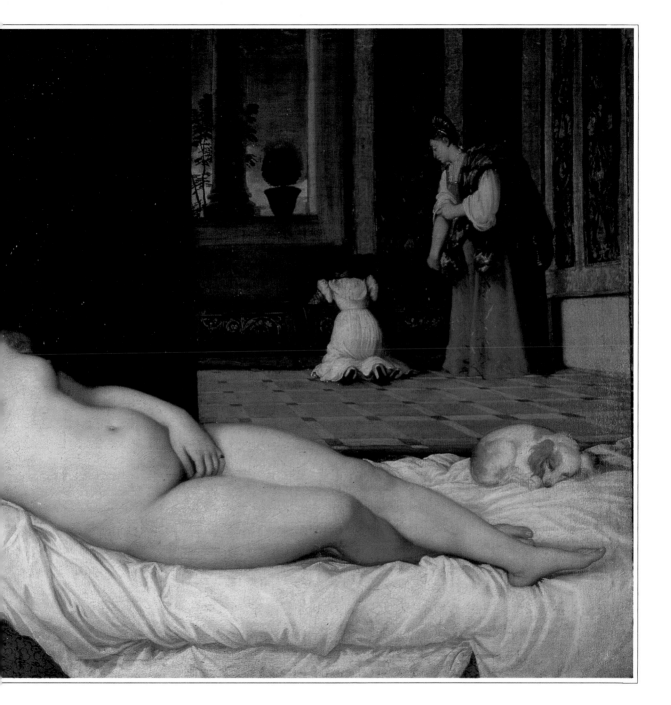

▷ The Toilet of Venus (Rokeby Venus)
Diego Velasquez (1599-1660)

Oil on canvas

THE FEMALE NUDE was extremely rare in Spanish art because the strong Spanish Catholic tradition engendered a reluctance to portray 'unchaste' subjects. However, some Spanish kings had a taste for Venetian nudes and this painting was almost certainly commissioned by Philip IV for his private collection. The subject shows the influence of Venetian art – Venus is shown reclining, absorbed by her study of the mirror (symbol of female vanity) which is held for her by a male cherub or Cupid (thus indicating that she is Venus). The model is seen in this unusual posterior view because this painting was intended as a companion piece, and counterpart, for a 16th century Venetian reclining nude. It also differs from Venetian models is that it lacks the opalescent voluptuous sensuality characteristic of Titian. Velasquez's typically restricted palette of milky flesh tones, dark greys and red make for a more austere handling of the erotic subject.

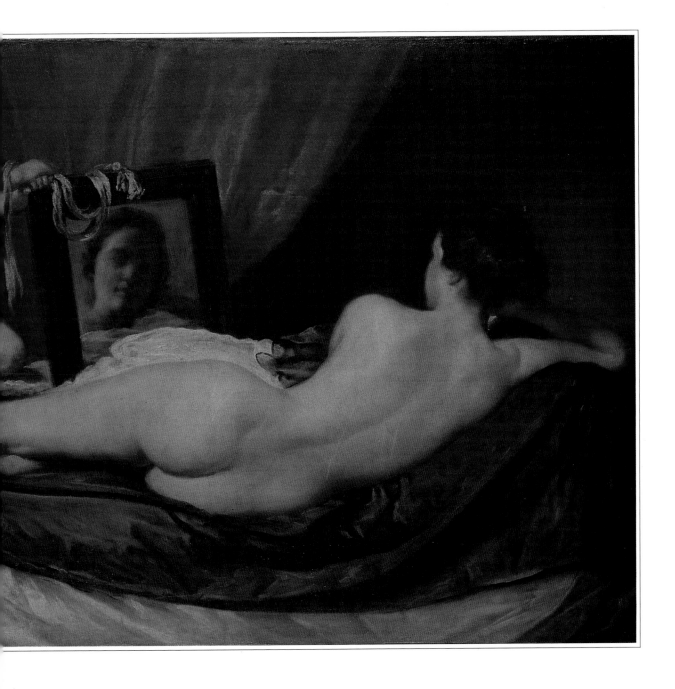

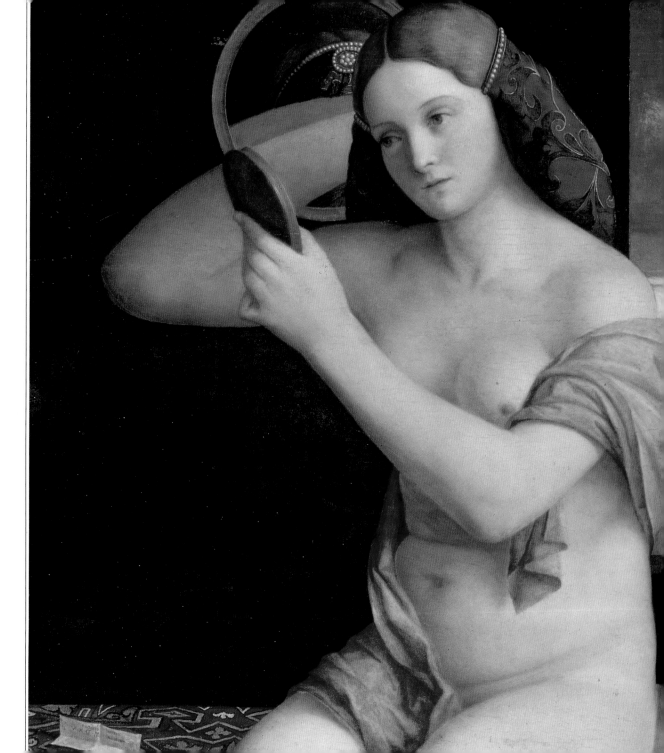

◁ **Young Woman with a Mirror** Giovanni Bellini (c.1430-1516)

Oil on canvas

KNOWN AS A PAINTER of Biblical subjects and Madonnas, in the last year of his life Bellini adapted one of his characteristic formats for the Madonna – a half-length figure centrally placed against a banner with a landscape setting beyond – for this female nude. It thus represents a milestone in the secularisation of painting. The nude, shown gazing intently and by implication admiringly at her own features in a mirror, was thought by Vasari to be related to a love poem by humanist Pietro Bembo. Though there are no classical references in the painting, there is an attempt to distance the figure by the alabaster smoothness with which it is painted, though the deep green backdrop only highlights the sensuality of the pearly whiteness of the young woman's flesh.

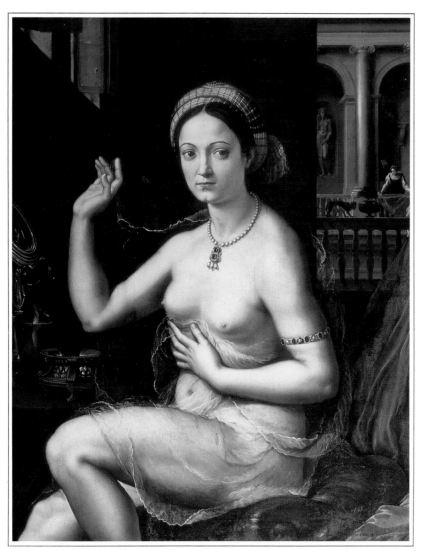

◁ **Woman with a Mirror**
Guilio Romano (1442/99-1546)

Oil on canvas

A PUPIL OF RAPHAEL, Romano is associated with the emotional restlessness and anxiety of Mannerism, a 16th century style quite different in mood from the Renaissance. The shift can be seen if one compares this painting to the more ordered world of the Bellini (page 29), for despite the identical subject of both – 'Vanity, thy name is woman' – the moods are quite different. Here, the female nude, richly if exotically accessorised, has been startled by someone or something to her left (as indicated by the direction of her gaze). In consequence, she raises her right hand and clutches her totally inadequate veils to her in a gesture of modesty. The sense of potential menace is reinforced by the spatial uncertainties of the composition, with its abrupt transition from dark shadow to deep architectural vista.

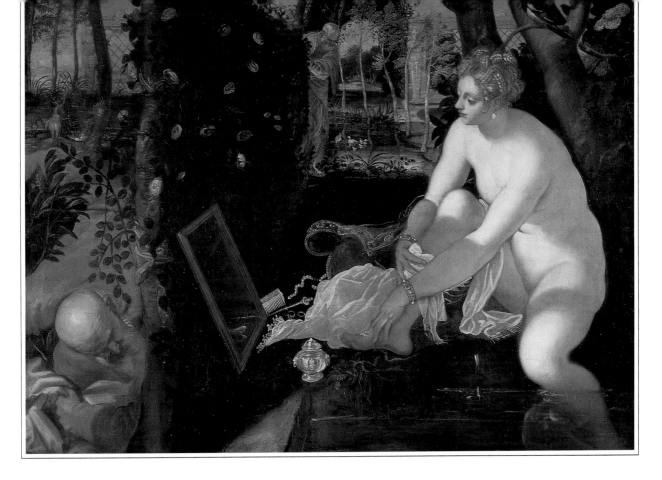

△ **Susannah Bathing** Jacopo Tintoretto (1518-94)

Oil on canvas

THIS PAINTING focuses upon the story of Susannah, exemplar of Old Testament womanly virtue. A chaste wife, she was covertly spied upon by community elders whil bathing. They subsequently threatened to accuse her of adultery if she did not submit to their advances but she refused to compromise her virtue. Tintoretto's treatment of the subject is rather awkward for the modern viewer who is forced to identify with the elderly male voyeurs. Our eyes, like theirs, focus upon the highlighted and voluptuous charms of Susannah. The Biblical message has been transformed from one of wifely virtue to female narcissism, even wantonness: Susannah gazes into a mirror, symbol of vanity, seemingly oblivious in her narcissistic reverie of the imminent threat to her honour.

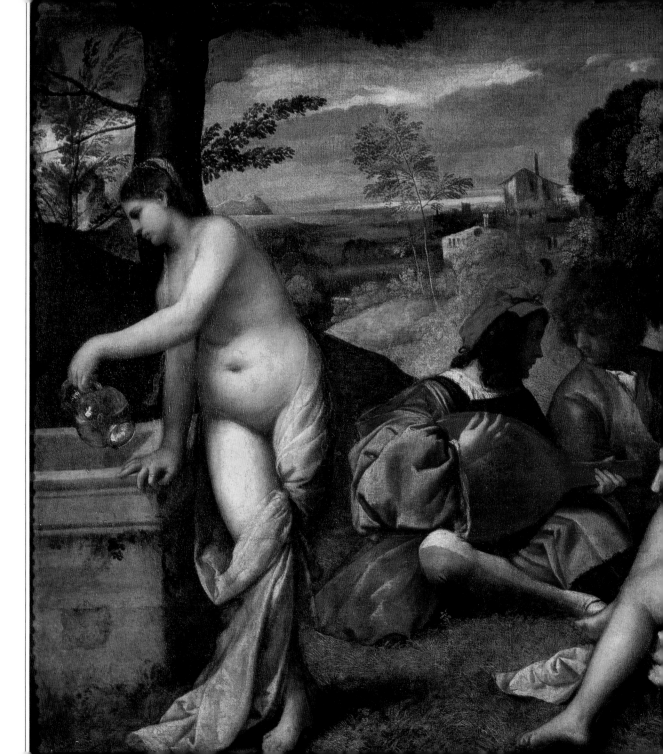

◁ **Concert Champêtre**
Titian (c.1487/90-1576)

Oil on canvas

EXECUTED VERY EARLY in
Titian's career, this painting
demonstrates Giorgione's
influence upon his painting.
The unity and strength of
colouring, geared toward
golds and greens and
highlighted by the red of the
central male figure, help to
mask the questions raised by
this painting. What is the
meaning of this group, so
provocatively arranged in such
a serene landscape setting? Is
it some erotic dalliance or does
it signify something more
profound? A clue to the most
likely interpretation must be
the conventional association of
woman with nature, man with
culture. The clothed males
symbolize the merits of
civilization, the female nudes
the beauties of nature.

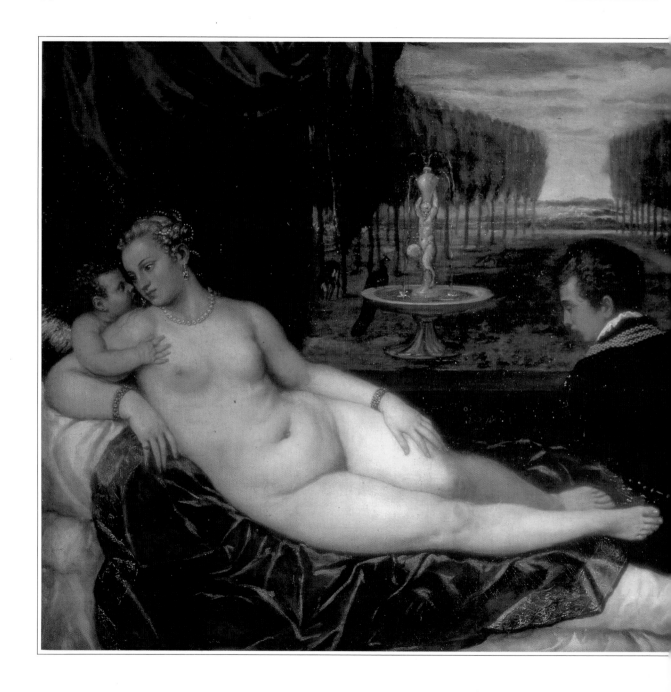

◁ **Venus and Cupid with Organ Player**
Titian (c.1487/90-1576)

Oil on canvas

TITIAN PAINTED five variations of nudes on a musical theme and the introduction of the musician, who seems to be playing for the goddess, was his own innovation. But his main concern is the representation of the sensual figure of Venus, goddess of love, shown reclining upon a bed, her attention caught by Cupid as he whispers in her ear. Her status as goddess of love is also indicated by the presence of an embracing couple in the formal garden behind, while the idea of female vanity may be suggested by the peacocks. In proportion this Venus is quite characteristic of the type of female beauty which Titian represented in his later paintings – more voluptuous than his earlier, her body almost too large for its graceful head. The golden opalescence of her skin and the softness with which the flesh is rendered, are also characteristic of the painter's later style.

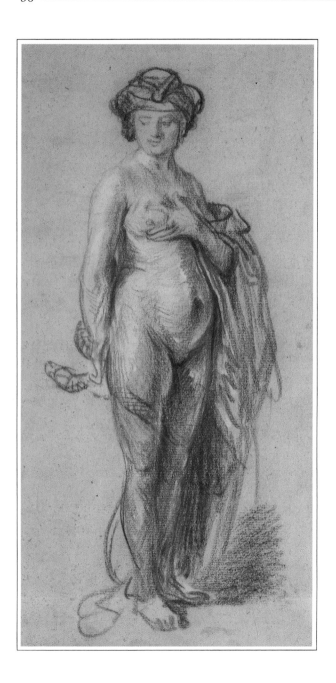

◁ **Study of a nude woman
as Cleopatra**
Rembrandt (1606-69)

Chalk drawing

REMBRANDT RAN A 'life' room
where students could go to
study from a female model, as
can be judged from his
drawings and those of his
students. Unlike Rubens with
his ideas about ideal female
beauty, Rembrandt's nudes
have a particularity. He is not
averse to showing the ravages
of time on naked female flesh
or, as in this case, glorying in
the plump attractiveness of a
model whose proportions
sugest a Dutch bourgeoise or
even servant woman (she is
not unlike Rembrandt's
second wife, Hendricke) rather
than a classical ideal. The
Cleopatra accessories may
reflect Rembrandt's fascination
with Biblical and Jewish
subjects.

▷ **The Three Graces**
Rubens (1577-1640)

Oil on canvas

RUBENS WAS VERY concerned with ideal female beauty, specifying that it included a long neck and hair, broad breast, straight back, ample but firm buttocks and full thighs. In this painting he has combined his ideal type with the personal. The figure on the left has the features of Helena Fourment, the painter's second wife, that on the right the features of Isabella Brandt, his first. Thus the artist has created an ideal link between his two spouses, but one charged with personal emotion. It is a commonplace to talk of the sensuality with which Rubens endowed the pearly flesh of his women but nowhere is it more apparent than in this late painting. The painting's private significance for Rubens is perhaps indicated by the fact that on his death his wife, Helena, wanted it destroyed.

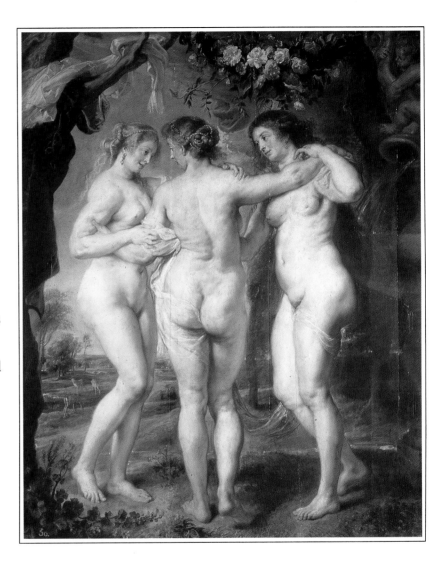

▷ **Bacchanal** Rubens (1577-1640)

Oil on canvas

THE HUMAN FIGURE was central to Rubens' art but that does not mean he was interested in rendering it realistically. His aim was to use the body to embody all kinds of meaning from Truth and Beauty to Gluttony and he would exaggerate physiognomy and bodily proportions to achieve the desired effect. Here the bodies depicted, despite the vigour of their actions, seem somehow slack. The baroque curve of the composition which creates the feeling of dissolute and rather chaotic activity is enhanced by the variation between the pale gold of the female centaurs and the rather coarse, ruddy skin tones of the male. All in all, Rubens has here used the nude to disgust, rather than more usual aim, to arouse.

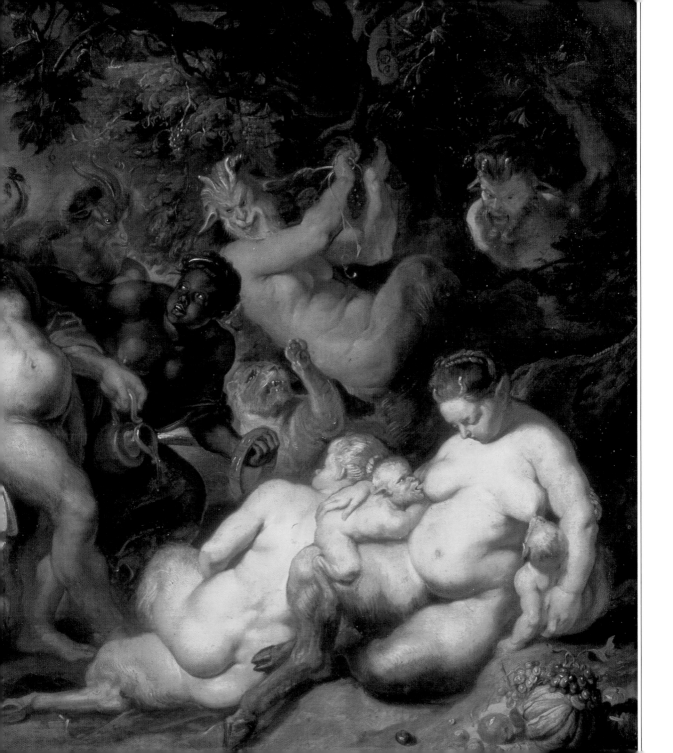

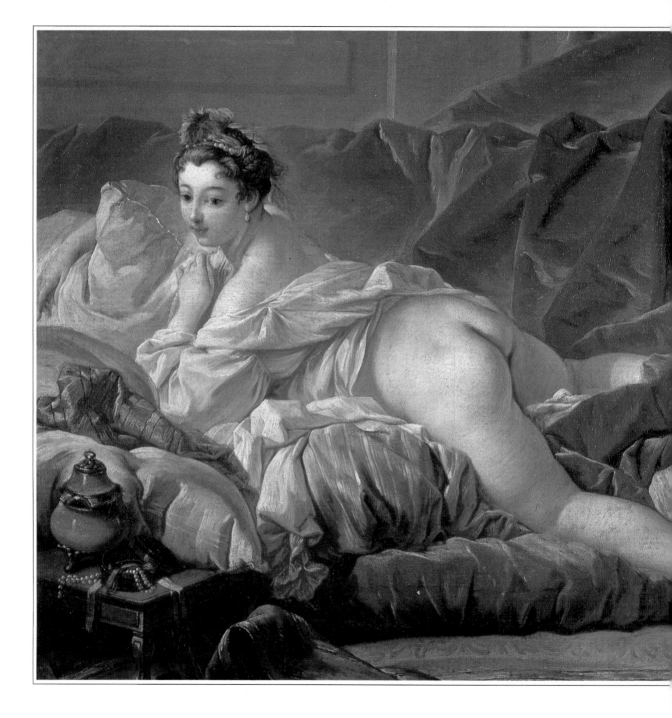

◁ **The Odalisque** Francois Boucher (1703-1770)

Oil on canvas

ROCOCO ART WAS designed to appeal to the sophisticated tastes of the French Royal court and to celebrate the atmosphere of gallantry and coquetry in which this social elite lived. Both subject and style emphasised sensuality and the seemingly artless but actually artificial. Boucher gloried in the erotic subject and this Odalisque (Turkish female slave) is one of a number of nudes in which there is almost no attempt to disguise the subject as mythological. The subject is thought to be Victoire O'Murphy, a member of the court around the King's mistress, Madame de Pompadour. Though beautifully painted, this nude is little more than a pretext for erotic titillation: the disarray of both model's robe and the draperies being designed to remind the (male) spectator of past sexual delight and offer a promise of more to come.

▷ Les Baigneuses
Jean-Honore Fragonard
(1732-1806)

Oil on canvas

FRAGONARD WAS PERHAPS the
last great painter in the rococo
tradition of the 18th century.
He enjoyed a considerable
reputation for painting nudes,
of which this is one of the most
exuberant examples. The
theme of bathers had many
precedents, though earlier
examples generally contained
more explicit mythological
references. Here the keynote is
the rather coquettish eroticism
which distinguishes rococo art.
These nudes disport
themselves with gay abandon,
particularly the central nude
who provocatively leaps with
arms outstretched while two of
her companions playfully
wrestle on the bank. The
earthiness of the theme is
emphasised by the artist's use
of fleshy pinks and warm
greens, while the joie de vivre
of the subject is enhanced by
the exuberance of the painting
technique.

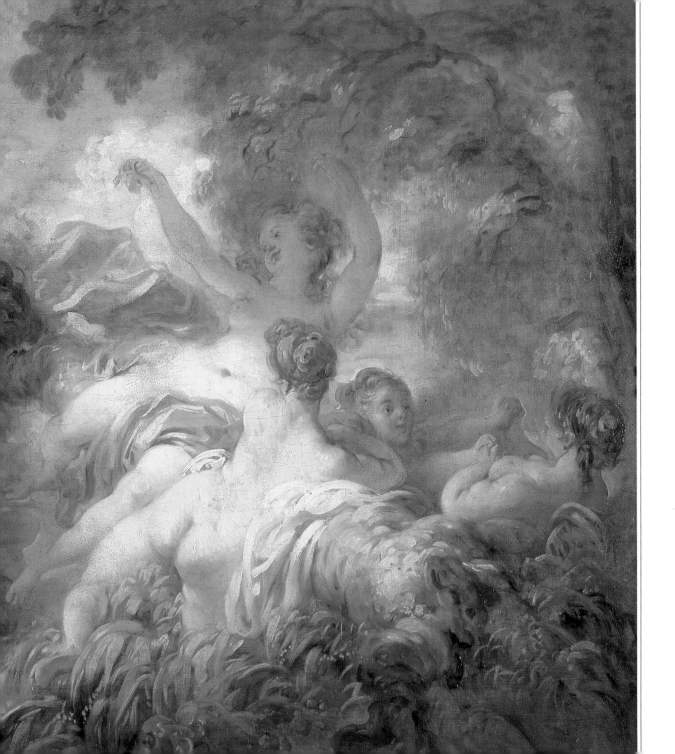

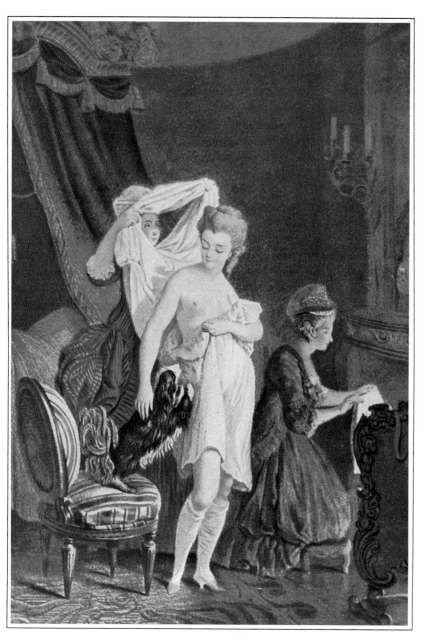

◁ **Getting Dressed**
Nicolas Francois Regnault

Engraving

THE TOILETTE WAS a favourite subject of rococo art. On the one hand it offered the chance to pass some moral judgement (in Hogarth's *Harlot's Progress,* for example); on the other, it provided an excuse for the erotic and the titillating. Paintings on this theme usually offered a more discreet view of the toilette than drawings and engravings which could, by virtue of their smaller scale and private circulation, be more frank. In this engraving the tone seems titillating rather than moral, with the woman as she is dressed by her maids, being interrupted by her dog tugging at her shift.

▷ **Satan and the Rebel Angels**
William Blake (1757-1827)

Watercolour

CONTOUR WAS SEEN by
Winckelmann (the great
German 18th century art
critic) as one of the
fundamental distinctions of
antique art and Blake shared
this view of line as the sign of
perfection in a work of art. He
was not, however, a
conventional neo-classicist; his
subjects were more often
derived from the Bible or
poetry. Also, his figures do not
reflect the decorous Greek-
centred classicism of Canova
(page 48), but in quality of
gesture and sense of exaltation
owe most to Michelangelo's
vigorous male nudes, which
were known to Blake from
engravings by Michelangelo's
mannerist followers. His
unique amalgam of the
classical and spiritual can be
judged from this watercolour,
one of a series of Biblical
subjects executed by Blake for
publisher Thomas Butts.

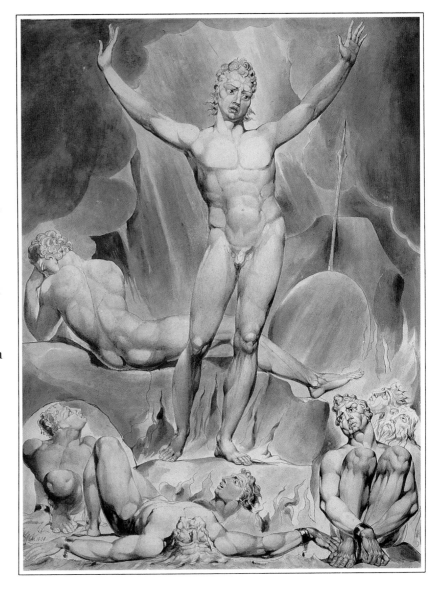

▷ **Leonidas at Thermopylae**
Jacques Louis David
(1748-1825)

Oil on canvas

NEO-CLASSICISM CALLED FOR an
art which did not pay too
much attention to nature or
detail but idealised in order to
express the highest emotions
and virtues. For Winckelmann,
the 'arts have a double aim: to
delight and to instruct': David,
a strong supporter of the
French Revolution, took up
the idea of an ethical purpose
for his art at the same time as
he determined 'to work in a
pure Greek style' drawing his
inspiration from antique
statues. The subject of this
treatment is Spartan heroes
preparing for battle and death,
their idealised male beauty
being a symbol for manly, and
more particularly Republican,
virtues such as steadfastness,
bravery and honesty. Each
figure was carefully drawn
from life, separately delineated
and contoured and then
arranged across the canvas as
in a frieze or a Greek vase
painting.

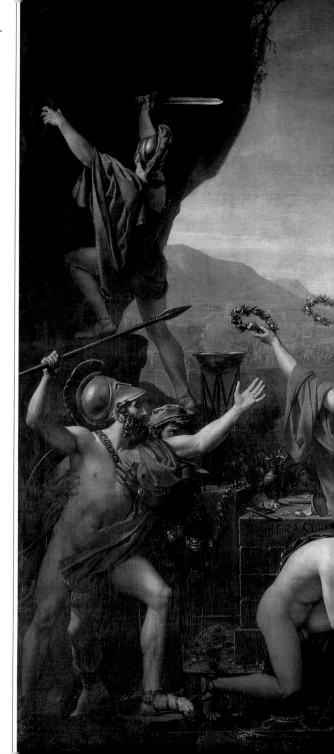

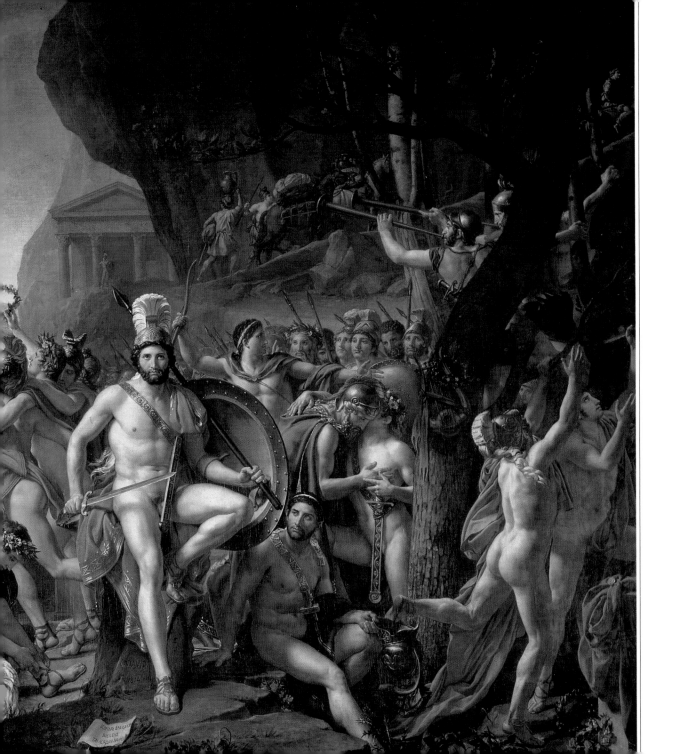

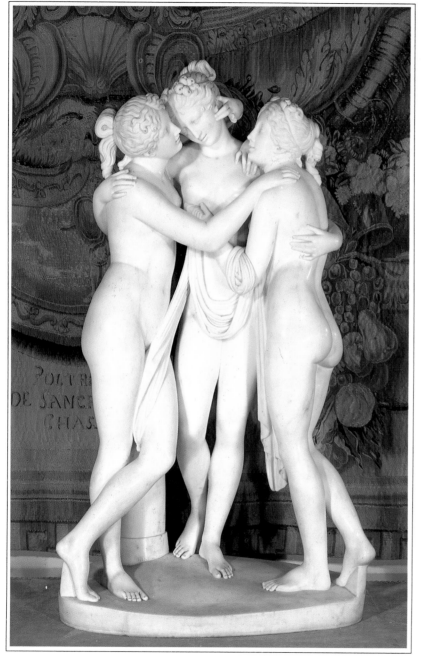

◁ The Three Graces
Antonio Canova (1757-1822)

Marble

TO THE SUPPORTERS of neo-classicism the purest forms of antique art carried and aroused the highest forms of feeling. Grace was the quality favoured by most British patrons with the Apollo Belvedere or Medici Venus the favoured models. Admirers acquired classical art when in Italy or commissioned contemporary sculptors to produce works exemplifying the classical spirit. In this work for the Duke of Bedford, the Italian sculptor Canova produced a graceful and charming rendition of a traditional antique theme (unusual in his reversal of the usual positioning of the Three Graces) which deliberately paid a debt to Greek sculpture. To many modern eyes, however, this work may appear rather sentimental in its rendition and insipid in the icy smoothness of its execution.

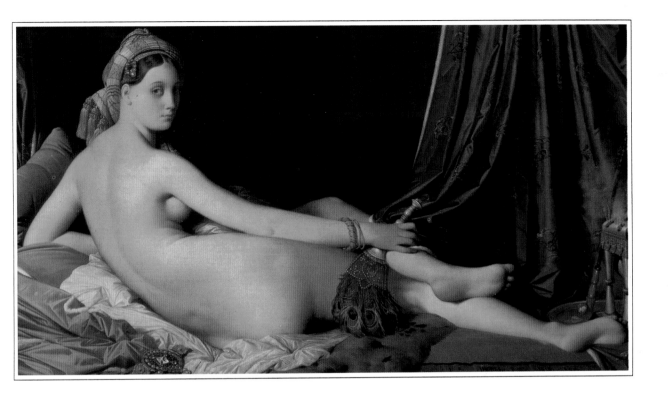

△ **La Grande Odalisque** Jean-Dominique Ingres (1780-1867)

Oil on canvas

INGRES CONTINUED the neo-classical insistence upon the primacy of line (equated with intellect) over colour (equated with sensuality). Here he combines superb draughtsmanship with the implicit sensuality of Orientalism (here signified by the turban style of headdress, the peacock feather fan, the rich brocades, the hookah pipe at the model's feet). But in contrast to the turbulence and violence of Delacroix's Sardanapolous (page 52), Ingres has subdued the erotic charge of his painting by the primacy placed upon design, upon creating a perfect arabesque. Indeed, what is most striking about this nude is how much the painter has wilfully distorted her for his own ends. No human could ever be the model for the great sweep of this nude's back, almost mannerist in its elongation, while one leg seems disjointed.

Detail

▷ **The Turkish Bath** Jean-Dominique Ingres (1780-1867)

Oil on canvas

ORIGINALLY COMMISSIONED by Prince Napoleon and rejected by him as too risqué, this painting entered the collection of Khalil Bey. The crowded Turkish Bath had been an object of fascination to western Europeans since the 18th century – Lady Montague wrote of her visit to one in Constantinople in 1718 – and Ingres seems to have been interested in the subject as early as 1819. The foreground figure playing a musical instrument is based upon Ingres' earlier *The*

Grand Bather (1808), a nude which expressed strong sensuality restrained and disciplined by form. But in this much later work, painted when Ingres was 82, the voluptuous charms of Eastern maidens seem no longer tamed by the neo-classical ideal of draughtsmanship. Instead the nudes in the foreground are almost piled on top of each other in an over- abundance of female flesh which creates an over-heated, even claustrophobic, eroticism.

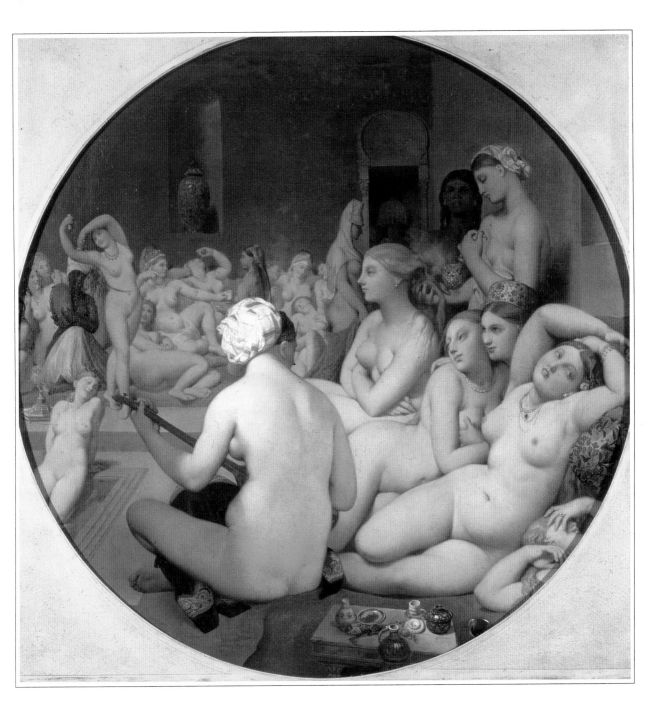

▷ **The Rape of Sardanapolous**
Eugene Delacroix (1798-1863)

Oil on canvas

BASED ON BYRON'S PLAY,
Sardanapolous, of a tyrant who,
threatened by defeat, decides
to destroy all his possessions
before committing suicide
himself, this painting combines
eroticism and the exotic in a
characteristically Romantic
fashion. Sardanapolous is
shown in the centre of a vortex
of destruction, reclining half in
light and half in shade upon
the kingly bed which will soon
be his funeral pyre: gloating as
all his favourite possessions are
brought before him to be
destroyed. The carnage is
highlighted by the golds and
reds of the colour scheme and
the swirling arabesques of the
composition. The horror of
the events is heightened by the
contrast between the dark
muscularity of the soldiers
carrying out Sardanapolous'
orders and the opalescent glow
of the tremulous concubines
brought before their lord to be
slaughtered (the last an image
not in the poem but of
Delacroix's own invention).

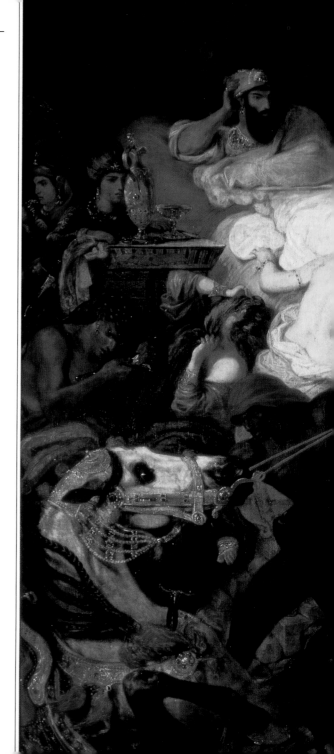

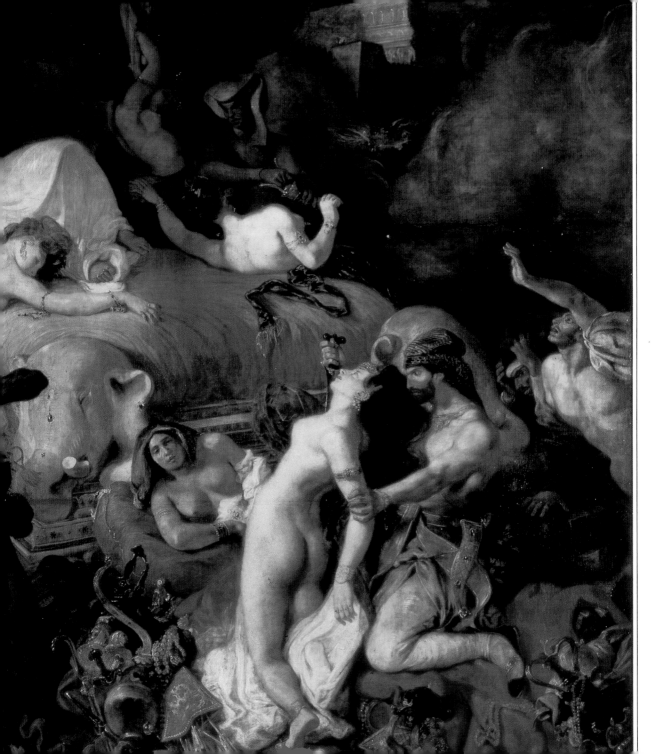

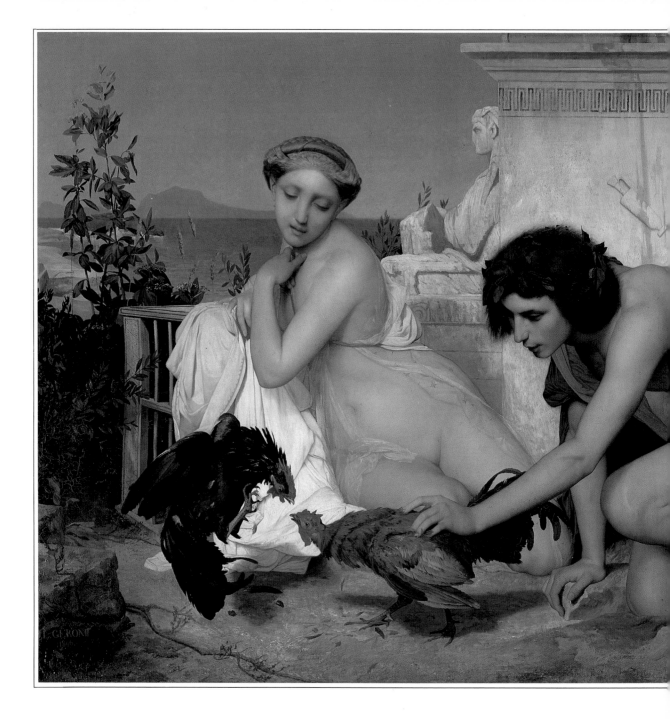

◁ **Young Greeks encouraging cocks to fight**
Jean Leon Gerome (1824- 1904)

Oil on canvas

DURING THE July Monarchy in France of 1830-48, the 'official' philosophy of art was the so-called *juste milieu* (the middle way). This was characterised by combination of neo-classical ideas with a leavening of Romanticism. Popular among the bourgeois art public, such paintings had none of the high moral tone of neo-classicism, but tended to be rather sentimental in subject and mood. The two classically beautiful figures are safely chastened (to contemporary eyes) by their classical setting; while their rather frivolous activity, a cock fight, gives the spectator the opportunity to weave his or her own narrative around the scene they were looking at.

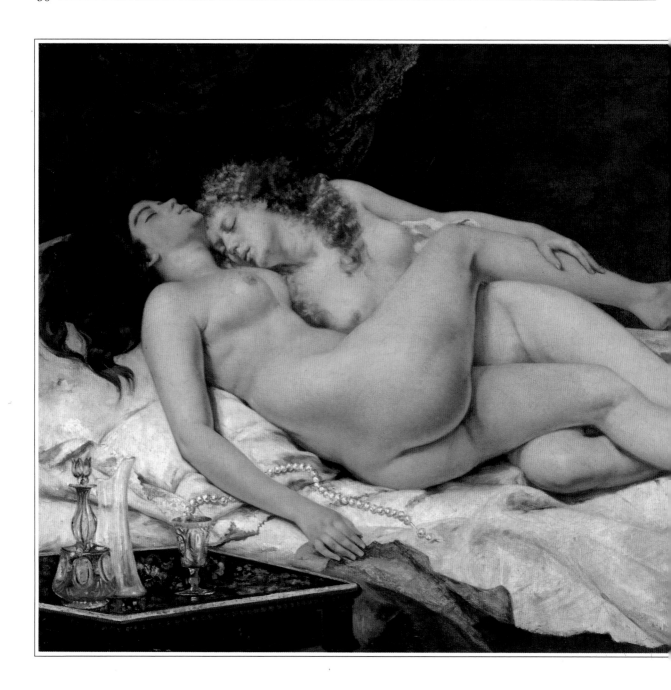

◁ **Le Sommeil** Gustave Courbet (1819-1877)

Oil on canvas

FROM THE 1840s ON Courbet painted a number of nudes in poses suggesting sleep or reverie. This, the most remarkable and frank, was painted for the Turkish Ambassador to Saint Petersburg, the Pasha Khalil Bey, a collector of erotica. Here, for private consumption only, is a portrayal of the staple male erotic fantasy, the aftermath of abandoned lesbian love (note the broken pearl necklace) – or at least what a man might imagine it to be! Above all the emphasis is upon flesh painting and here presented for the Pasha's delectation is a contrast between the pearly translucency of the sleeping blonde and the warm olive flesh tones of the foreground brunette, the figures intertwined carefully around the other in a way which artfully ensures that all erotic signs are carefully presented to view.

▷ **The Birth of Venus**
Alexandre Cabanel
(1823-1889)

Oil on canvas

PAINTED IN THE same year as Manet's *Olympia* (pages 62-63), this Venus exemplifies the kind of nude most acceptable to the French public. Venus, languidly reposing, floats into shore on surf as solid as a green velvet couch, her mythological status indicated by the presence of the five gambolling putti (children) who take the place of the Zephyrs of mythology. This painting shows how the convention of the nude had degenerated since Botticelli's rendition of the same theme in the fifteenth century (page 15). Where that painting had been almost chaste in its mixture of the antique and the Gothic, in Cabanel's work the always uneasy attempt, since the time of Giorgione and Titian, to contain eroticism in classical clothing seems to have broken down. The result is to modern eyes distressingly vulgar, the essential lubricity of the subject barely concealed by the marble iciness of Venus's pearly flesh.

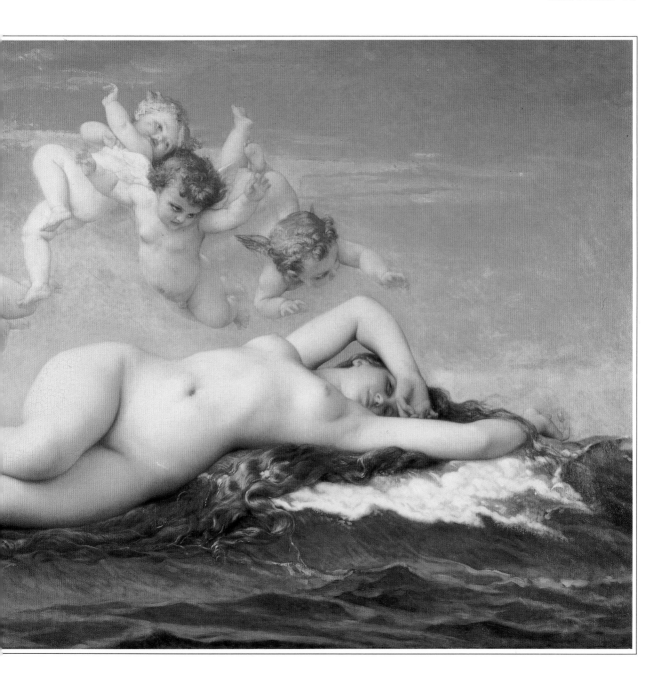

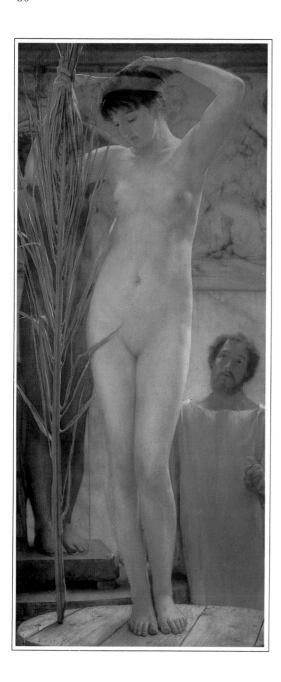

◁ The Sculptor's Model
(Venus Esquilana)
Sir Lawrence Alma-Tadema
(1836-1912):

Oil on canvas

IN ENGLAND, as in France, lip service was paid to the notion of the female nude as an exemplar of ideal beauty, allowable if distanced by a suitable classical subject, although such subjects were less common in the annual exhibitions of the British Royal Academy than its French counterpart. Here we are shown the myth of Pygmalion, a sculptor who falls in love with a statue he has made and has his wish that she be brought to life granted by the gods. In this painting Alma-Tadema presents the nude in a manner that would have found favour with the Victorian public, the nudity rendered unprovocative by its classical setting and the icy smoothness with which it is painted.

▷ **The Bathers**
Gustave Courbet
(1819-1877)

Oil on canvas

COURBET'S *Realist Manifesto* of
1849 called for an art dealing
only with what the artist could
see and touch, and asked that
the artist portray the world
around him rather than
history, literature or religious
events. It is in this spirit that
he produced this painting.
True, there is the stage setting
for a literary or mythological
tale: a leafy glade, a female
bather and her companion,
presumably her maid servant.
But what is emphasised is the
corporeality of the central
female figure, picked out by
the shaft of sunlight piercing
through the trees into this
hidden glade; her amplitude
as she sets off for her bathe
marking her out as a
bourgeoise rather than a
goddess. This treatment
proved controversial – when
shown at the Paris Salon in
1853 Napoleon III is reputed
to have struck the bottom of
the ample bather in a gesture
of disgust.

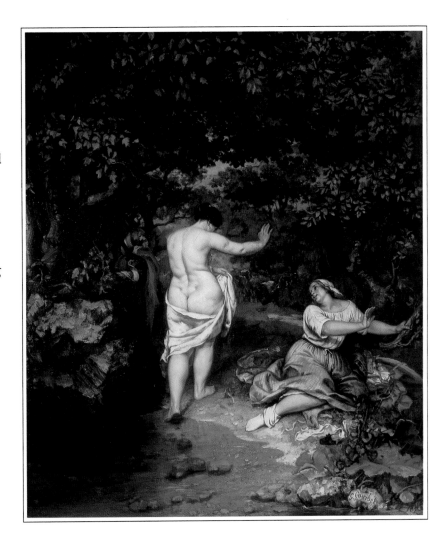

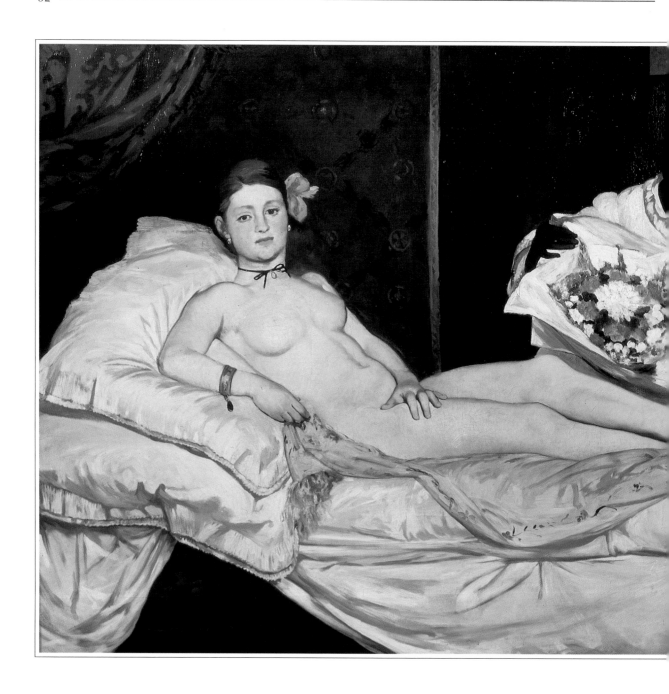

◁ **Olympia** Edouard Manet (1832-83)

Oil on canvas

Olympia IS EFFECTIVELY a re-working of Titian's *Venus of Urbino* (page 24) and should be seen as Manet's attempt to rework the nude in a way more appropriate for the second half of the 19th century. Despite this it was a public scandal when first exhibited at the 1865 Salon. It was considered an affront to public decency; the occasion of much written comment and a field day for cartoonists. Critics railed against the 'brutish ugliness of a model picked out of the gutter', her 'vulgarity bordering on indecency', her hand 'flexed' provocatively across her sex. Today's viewer is more likely to be struck by the opulence of her satin sheets; the silky embroidered shawl upon which she reclines; the fashionable black maid who brings her an admirer's bouquet. Contemporary distress resided partly in the vitality of Manet's painting technique but also in the fact that Olympia's coolly provocative gaze is quite different to the demurely averted eyes of conventional nudes.

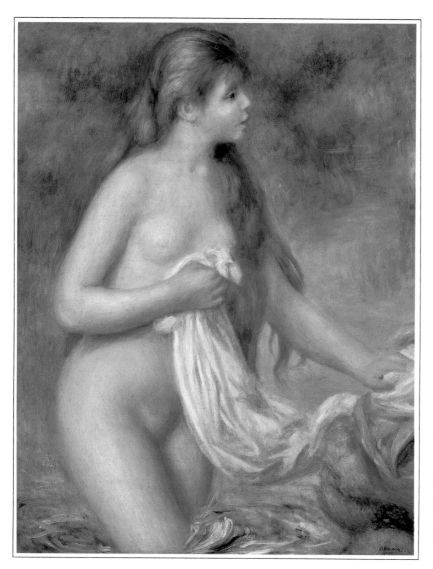

◁ **Bather with Long Hair**
Pierre Auguste Renoir
(1841-1919)

Oil on canvas

TO RENOIR 'one can invent
nothing better' than the
eternal subject of 'a nude
woman getting out of the briny
deep or out of her bed,
whether she is called Venus or
Nini'. In this interest he stands
apart from the preoccupation
with landscape and modern
life subjects which
distinguished most of the
Impressionist painters. The
only other Impressionist to
devote as much time to the
figure was Degas (page 67).
This nude, painted after
Renoir's re-appraisal of
Impressionism in the 1880s,
demonstrates his later concern
with a more solid form
softened by a sensuous
painterly technique. In it one
can see the characteristic
emphasis upon charm which
has made such paintings
perennially popular. As
Theodore Duret said: 'his
rapid, light brush strokes give
an effect of grace, abandon ...
his women are enchantresses'.

▷ **Baigneuse**
Pierre August Renoir
(1841-1919)

Oil on canvas

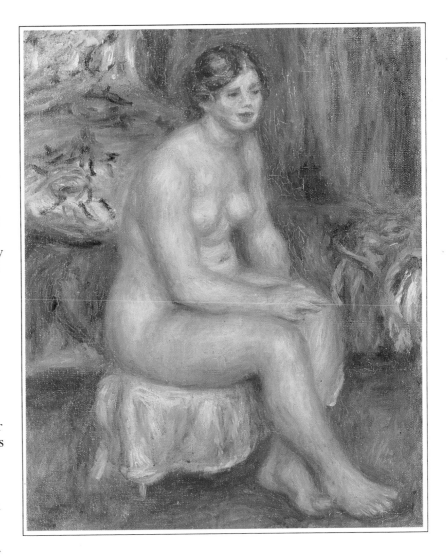

IN THE LAST DECADE of his life
the nude 'bather' was central
to Renoir's work and came
almost to have the quality of a
personal vision. His ever-
increasing delight in the
roundness of body forms such
as shoulder, breast, buttock
and thigh led him increasingly
to enlarge and exaggerate the
bodies of his nudes, until one
arrives at the rather over-
heated pneumatic charms of
this Baigneuse. The bulk of
the figure is further
highlighted by the relative
smallness of the head which
seems to perch rather
incongruously upon the bulk
of hips and thighs. The colour
schemes for these late nudes is
dominated by orange, pink
and yellows; here the only
touches of coolness are
provided by green patterns in
the background chintz. What
unites this work with his
earlier painting is the delicacy
of his brush stroke, all the
more remarkable as he was by
this time crippled with
arthritis.

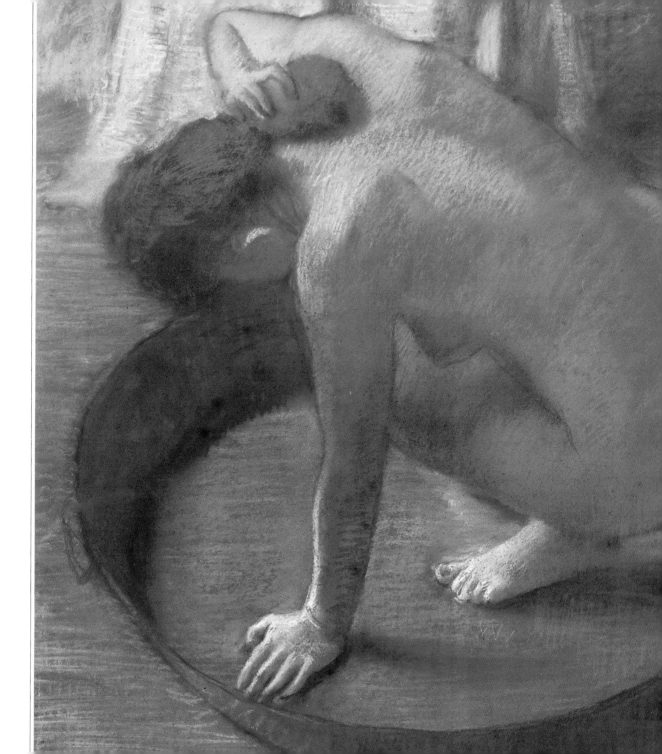

◁ **Le Tub**
Edgar Degas (1834-1917)

Pastel

IN ONE OF ten pastels he exhibited at the last Impressionist exhibition in 1886, Degas builds up layer upon layer of pastel to create stunning effects of colour harmony and contrast, stretching the medium of pastel to heights not seen since the rococo period. Apparently natural and artless in his effects, Degas actually arranged his bathers in the studio and depicted them from odd high angles inspired by the influences of photography and Japanese prints. These women washing themselves or being washed are very different in mood to Renoir's deliberately pleasing nymphets or earth mothers. Self-absorbed and twisted into the awkward positions of the toilette, they have little in the way of deliberate charm. Indeed, contemporary critics described them as 'ugly', 'swollen' and 'debased'. To modern eyes, there is a worrying undercurrent of misogyny in the way the vantage point suggests the keyhole of the peeping Tom.

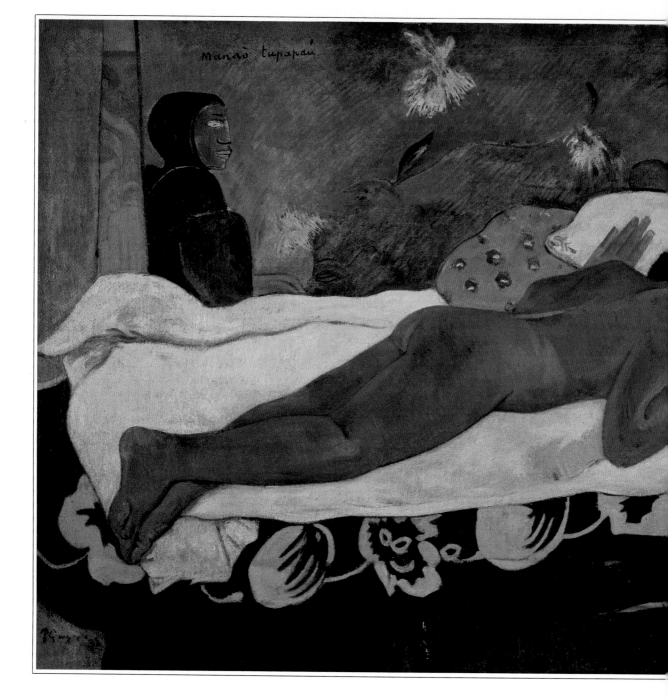

◁ **Manao Tupapau** *(The spirit of the dead keeps watch)*
Paul Gauguin (1848-1903)

Oil on canvas

THIS PAINTING WAS produced during Gauguin's first trip to Tahiti in 1892, where he went to try and experience a simpler, more 'primitive', way of life. In it the artist aimed to convey the superstitious belief of the Tahitians in the spirit world with, he hoped, as little in the way of literary means as possible. Colours are exaggerated and the nude figure of a young Tahitian girl is shown tensely stretched, her dark flesh contrasted to the white sheets on which she lies. Gauguin described the painting thus in his autobiography *Noa-Noa:* 'To sum it up: the musical part, undulating horizontal lines, harmonies of orange and blue brought together by yellows and purples which are lighted by greenish sparks; the literary part, the spirit of a living soul united with the spirit of the dead. Day and night.'

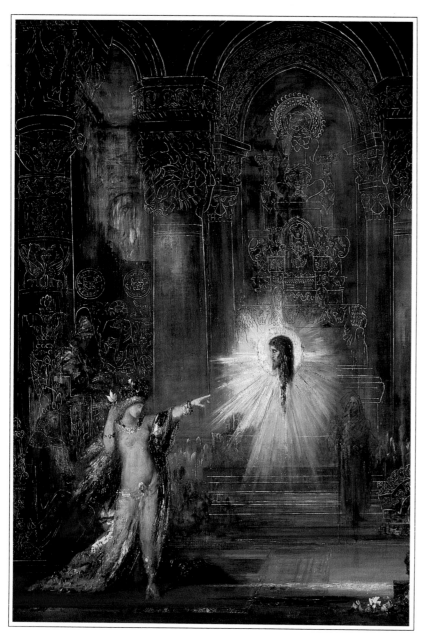

◁ **The Apparition**
Gustave Moreau (1826-98)

Oil on canvas

LATE 19TH CENTURY literature demonstrates a strong and misogynistic fascination with the portrayal of the *femme fatale,* devourer and emasculator of men. This concern found expression in a number of themes: Sphinx, Medusa, Judith, Delilah and Salome. In this painting, one of a number he executed on the same theme, Moreau shows Salome, who persuaded her step-father Herod, through her seductive dance of the seven veils, to promise her the head of the prophet, John the Baptist, on a platter. Confronted by a vision of the consequences of her dance Salome, as a true femme fatale, rather than appearing contrite, gestures triumphantly toward the apparition. The disquieting mood is heightened by touches of brilliant detail in Salome's scant accessories and the almost Hindu feeling of the setting in which she dances.

▷ **Madonna**
Edvard Munch (1863-1944)
© THE MUNCH MUSEUM/
THE MUNCH-ELLINGSEN
GROUP/DACS 1995

Oil on canvas

THIS *Madonna,* DESPITE the her title, is no succourer and provider of life, but a femme fatale, focus of male fears in the last years of the 19th century as the 'new woman' emerged and threatened the status quo. The message of woman's power over life and death, or more particularly the femme fatale's refusal to procreate, is made explicit in the lithograph of the same title, in which sperm-like forms are swim around the border. In this painting the woman seems to loom threateningly large in the frame. Her eyes are closed, her gaze is turned inward, she is sated, in a post-orgasmic torpor, by implication having sucked out the man's vital energies like a vampire. The theme of rapacious femininity is further reiterated by Munch's use of colour, the red of blood and the dark of night broken only by the pearly lure of tempting and deadly female flesh.

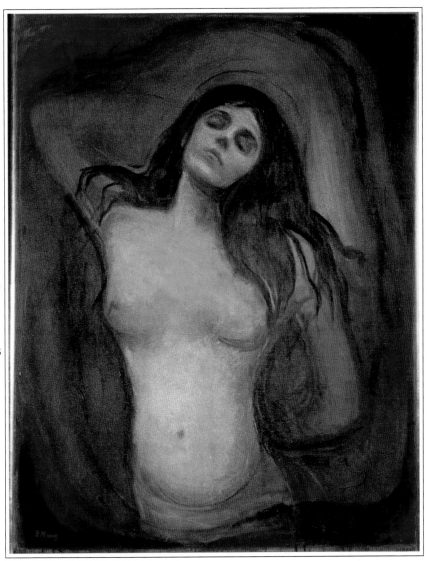

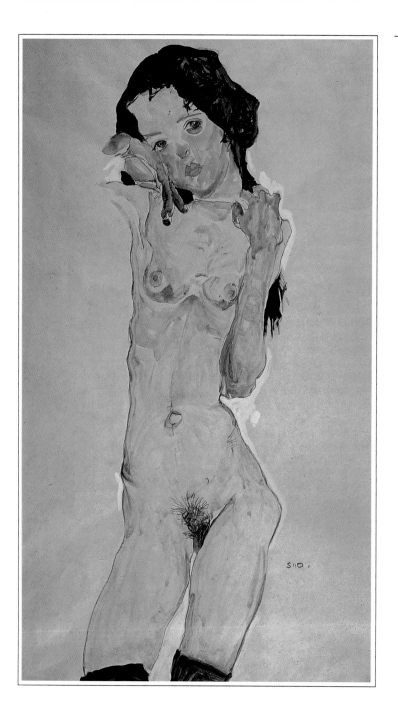

◁ **Nude black-haired Girl**
Egon Schiele (1890-1918)

Watercolour

ACCUSATIONS OF pornography dogged Schiele in early 20th century Vienna. This was undoubtedly because he had an interest in sexuality as a source of artistic inspiration and his paintings of nudes have an 'up-front', even anatomical, character which made them seem morally dubious to his contemporaries. Among the most shocking of his works were the extremely explicit self-portraits and series of studies of pubescent girls he produced in 1910. The blossoming of sexuality is emphasised in the pliancy of the model's pose, in the budding breasts but most especially in the deliberate highlighting of lips and pubis. Anxious to counter the accusations of pornography, Schiele stated with some bitterness at the time: 'I certainly didn't feel erotic when I made them!', but this image undoubtedly has a disturbing erotic edge to it.

▷ Female Nude
Amedeo Modigliani
(1884-1920)

Oil on canvas

MODIGLIANI'S NUDES are an amalgam of the real and the abstract. Anatomy and facial type are stylized and simplified – a characteristic distortion is the swan-neck of the model – while different parts of the body are delineated by a dark outline. The colour too is rather non-naturalistic, almost as if the figure has been created from terracotta. One might think that this level of abstraction would subdue the erotic potential of the nude. Yet it has a profound sexual charge. Part of the reason for this must reside in the inclusion of very realistic detail such as public hair and rosy pink nipples. Indeed, paintings such as this *Female Nude* were considered obscene by Modigliani's contemporaries and his first and only solo exhibition in Paris in 1917 was closed by the police on the grounds of obscenity.

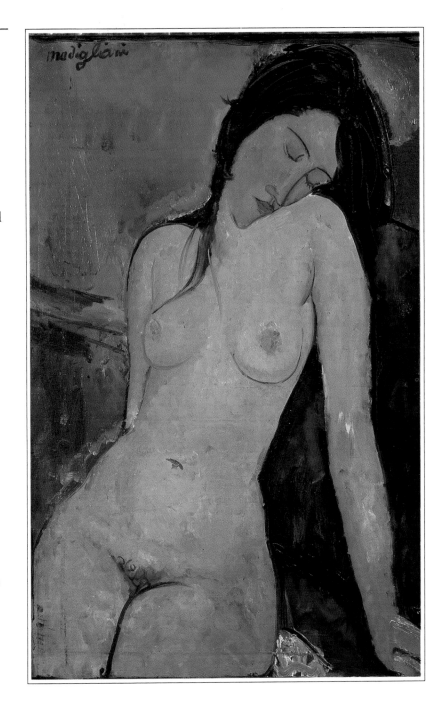

▷ **Demoiselles d'Avignon** Pablo Picasso (1881-1972)
© DACS 1995

Oil on canvas

THIS PAINTING STRONGLY challenged the conventions of the nude, particularly in the character of the females depicted, more harpies than odalisques. The subject of this painting is the brothel (the Calle d'Avignon was a street in the red-light district in the painter's home town of Barcelona); the message is of the eternal presence of death in life, a kind of linking of sex and death common in late nineteenth century Symbolist art. Though the obvious symbols of this meaning are omitted here (they are present in the preparatory studies), Picasso expresses his theme in this painting through his use of aspects of primitive, and particularly tribal African, art. The whores of Avignon, sharp and de-eroticised, challenge and threaten the spectator (presumably male) by their gaze and the way their forms rush forward in the crushed space available.

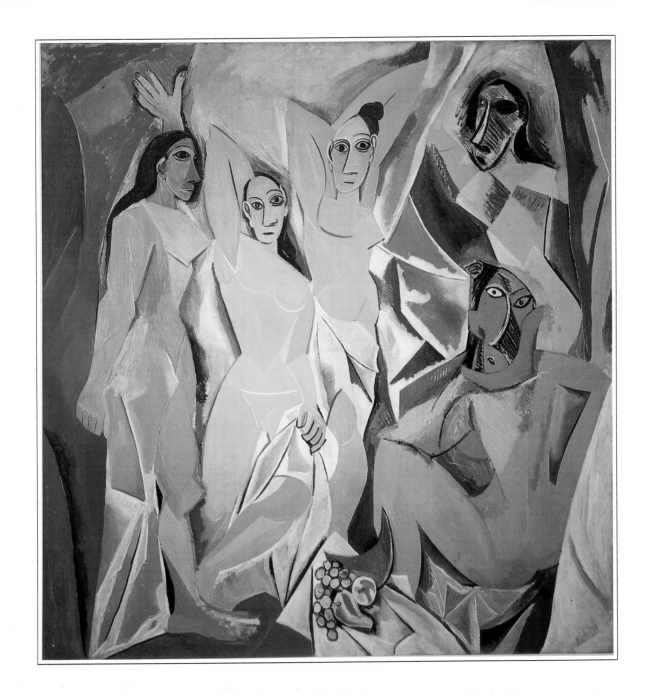

▷ **Two Young Girls** Erich Heckel (1883-1970)
© DACS 1995

Oil on canvas

HECKEL WAS A member of a group of young German painters, 'Die Brucke' (The Bridge), who took up the nude as a signifier of the 'primitive'. To them the 'primitive' signified innocence, a lack of sexual taboo, freedom of spirit and being in touch with nature; all thought to have been lost by modern society. As part of a bohemian revolt against society, the artists would go into the countryside during the summer months to try and recapture the primitive ideal, both in life and in their art. These young women are depicted not in the conventionalised poses of the artist's studio but at ease in a pastoral setting and unabashed by their nakedness. Woman is presented as synonymous with nature. The implicit attack upon convention is heightened by the strong use of colour and the stylisation and strong outlining of the forms.

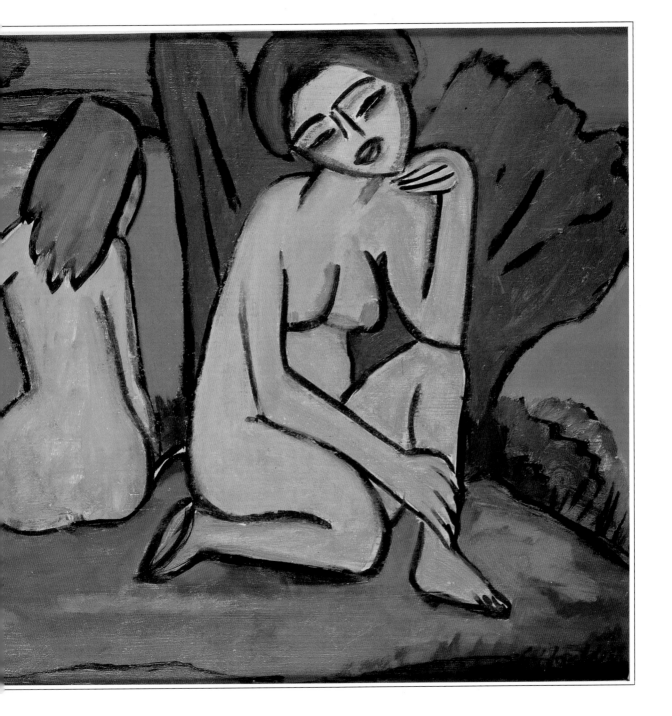

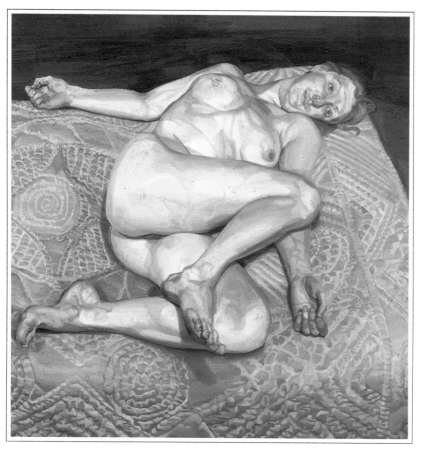

◁ **Night Portrait**
Lucien Freud (born 1922)

Oil on canvas

FREUD'S NUDES POINT to how
the nude in the 20th century is
no longer about notions of
beauty or truth but a vehicle
for the artist's private vision.
Freud's nudes are by an artist
whose gaze is unblinking and
terrible in its intensity. These
figures are not nude; they are
naked, even stripped. *Night
Portrait* is perhaps unusual in
that it does not share the brutal
way Freud usually captures
every imperfection of form; the
almost surgical way blotchy
skin or boniness of form is
depicted; the way his nudes
usually lie sprawled tensely
and uncomfortably before the
artist upon rumpled bed or
couch. Here the mood is
comparatively gentle. The body
of the young woman is relaxed,
her arms are spread upon a
neatly made pink counterpane
and she has a gently reflective
look on her face.

ACKNOWLEDGEMENTS

The Publisher would like to thank the following for their kind permission to reproduce the paintings in this book:

Bridgeman Art Library, London /Vatican Museums & Galleries, Rome: 8; /**Louvre, Paris:** 9, 42-43; /**Musee Conde, Chantilly/Giraudon:** 10-11; /**Kunsthistorisches Museum, Vienna:** 12, 28-29, 31; /**Brancacci Chapel, Santa Maria del Carmine, Florence:** 13; /**Galleria degli Uffizi, Florence:** 14, 16, 24-25; /**Christie's, London:** 17, 36, 60, 65, 76-77; /**Louvre, Paris/Giraudon:** 18-19, 32-33, 40-41, 46-47, 49, 50-53; /**Gabinetto Disegni e Stampe, Uffizi, Florence:** 20-21; /**Galleria dell'Accademia, Florence:** 22; /**National Gallery, London:** 26-27; /**Pushkin Museum, Moscow:** 30, 38-39; /**Prado, Madrid:** 34-35, **37**/**Private Collection:** 44, 78; /**Victoria & Albert Museum, London:** 45; /**Belvoir Castle, Leicestershire:** 48; /**Musee d'Orsay, Paris/Giraudon:** Cover, Half-title, 54-55, 58-59, 62-64, 66-67; /**Musee du Petit Palais, Paris:** 56-57; /**Musee Fabre, Montpellier:** 61; /**Albright-Knox Art Gallery, Buffalo, New York:** 68-69; /**Musee Gustave Moreau, Paris:** 70; /**Nasjonalgalleriet, Oslo:** 71; /**Graphische Sammlung Albertina, Vienna:** 72; /**Courtauld Institute Galleries, University of London:** 73; /**Museum of Modern Art, New York:** 75; © **Nippon Television Network Corporation, Tokyo 1994:** 23